U0137581

嚴復翰墨輯珍

嚴復信札選輯

主　編　鄭志宇
副主編　陳燦峰

海峽出版發行集團
THE STRAITS PUBLISHING & DISTRIBUTING GROUP ｜福建教育出版社

京兆叢書

出品人 \ 總策劃
鄭志宇

嚴復翰墨輯珍

嚴復信札選輯

主編

鄭志宇

副主編

陳燦峰

顧問

嚴倬雲 嚴停雲 謝辰生 嚴正 吳敏生

編委

陳白菱 閆巽 嚴家鴻 林鋆
付曉楠 鄭欣悦 游憶君

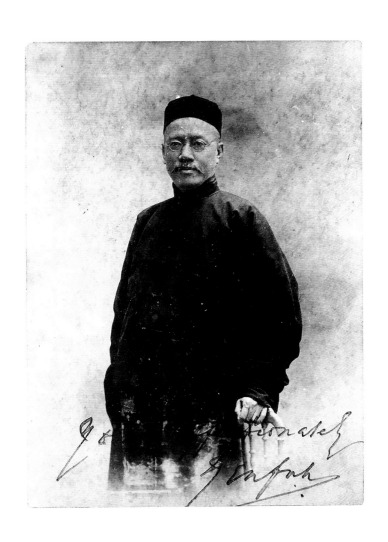

嚴 復

（1854 年 1 月 8 日—1921 年 10 月 27 日）

原名宗光，字又陵，後改名復，字幾道。

近代極具影響力的啟蒙思想家、翻譯家、教育家，新法家代表人物。

《京兆叢書》總序

予所收蓄，不必終予身爲予有，但使永存吾土，世傳有緒。

——張伯駒

作爲人類特有的社會活動，收藏折射出因人而異的理念和多種多樣的價值追求——藝術、財富、情感、思想、品味。而在衆多理念中，張伯駒的這句話毫無疑問代表了收藏人的最高境界和價值追求——從年輕時賣掉自己的房産甚至不惜舉債去換得《平復帖》《游春圖》等國寶級名跡，到多年後無償捐給國家的義舉。先生這種愛祖國、愛民族，費盡心血一生爲文化，不惜身家性命，重道義、重友誼，冰雪肝膽賫志念一統，豪氣萬古淩霄的崇高理念和高潔品質，正是我們編輯出版《京兆叢書》的初衷。

"京兆"之名，取自嚴復翰墨館館藏近代篆刻大家陳巨來爲張伯駒所刻自用葫蘆形"京兆"牙印，此印僅被張伯駒鈐蓋在所藏最珍貴的國寶級書畫珍品上。張伯駒先生對藝術文化的追求、對收藏精神的執著、對家國大義的深情，都深深融入這一方小小的印章上。因此，此印已不僅僅是一個符號、一個印記、一個收藏章，反而因個人的情懷力量積累出更大的能量，是一枚代表"保護"和"傳承"中國優秀文化遺産和藝術精髓的重要印記。

以"京兆"二字爲叢書命名，既是我們編纂書籍、收藏文物的初衷和使命，也是對先輩崇高精神的傳承和解讀。

《京兆叢書》將以嚴復翰墨館館藏嚴復傳世書法以及明清近現代書畫、文獻、篆刻、田黃等文物精品爲核心，以學術性和藝術性的策劃爲思路，以高清畫册和學術專著的形式，來對諸多特色收藏選題和稀見藏品進行針對性的展示與解讀。

我們希望"京兆"系列叢書，是因傳承而自帶韻味的書籍，它連接着百年前的群星閃耀，更願化作攀登的階梯，用藝術的撫慰、歷史的厚重、思想的通透、愛國的情懷，托起新時代的群星，照亮新征程的坦途。

《嚴復信札選輯》簡介

　　明清以來，信札作爲古人日常交往、交流的重要手段，日益凸顯其在文化生活中的重要地位；尤其到了晚清，文人對於信札的書寫和保存更加重視，在信札用紙和形式方面都十分用心，因爲到了此時，信札已經從一種古人日常溝通的媒介，變成兼具實用性、藝術性與文獻價值的特殊作品。到了如今，信札作爲研究歷史故實與名人生平、藝術的重要資料，其多方面的重要價值已經受到廣泛的關注與認可。

　　本輯所選嚴復信札，分中文信札和英文信札兩類，其致信對象包括嚴復子女、親戚、學生、朋友等，寫信地點則分布在北京、天津、上海以及福州等地。信札中所涉及之事，從家長里短到工作生活，再到社會大事與國際風雲，可以説事無巨細，真情流露，無論對於嚴復生平及其交游的研究，還是作爲中國近代史相關領域資料的補充，都是一份相當珍貴的史料。

　　嚴復致其子女的家書，最能反映嚴復真實的情感、思想以及晚年生活細節。1918 年 11 月，嚴復因要送三子嚴琥（叔夏）回福建完婚而離京南下，在此月寫給嚴璸、嚴璆、嚴瓏、嚴頊等子女的家書中提到他身體抱恙，故請天津的德籍醫師容克看病，并戲言其族弟嚴文炳（彬亭）的占卜似乎又要靈驗。嚴復擔心路上寒冷，本擬打算早點南下，但前後又在天津耽擱了十七八日，恐就是病情所致。蓋嚴復晚年飽受烟癮纏身之苦，且常伴咳嗽、筋跳、失眠等病癥，據年譜及相關文集可知其每每病犯，幾無例外必延西醫，且偶行占卜事。第二年春嚴復自閩來滬，於六月至八月間入上海紅十字醫院治病。在此時寫給嚴大、嚴四小姐的信中，嚴復先跟女兒閑聊天氣之悶熱以致無法入睡，又問及三子嚴琥、長子嚴璩的行程，并詢問北京遷居之事，最後又將此次住院的各項費用告知二女及家人。信中所提及的"阮府"即北京東城大阮府胡同，是年底嚴復與家人搬進新居，乃自號"癙壄草堂"。而在 1921 年春寫於福州郎官巷的信中，嚴復提到他到醫院檢查肺病，因年邁擔心身體負擔且行程耽擱，故對坐火車北上的行程作了安排，要長子嚴璩和學生伍光建共同設法聯係在浦口當差的前水師學堂學生吳夢蘭，希望到時給些關照。可見，在晚年嚴復的生活中，身體抱恙是常態，而他在面對病痛時以西醫之法治療、以中醫占卜問訊，某種程度也可窺見其晚年對於中西文化的矛盾態度。

　　除了子女外，嚴復對於外甥女何紉蘭與侄子嚴培南、嚴伯鋆等也都十分關心，常有書信寄給對方。何紉蘭爲嚴復在馬尾船政局及留英時的同學何心川與嚴復大妹之女，嚴復對此外甥女十分疼愛，在 1912 年他擔任北大校長的最後時光裏，曾有信寫給何紉蘭，信中雖未詳細談論北京大學具體情況，

然字句中所透露出來的無奈之情則顯而易見。而在一封給嚴培南的信中，嚴復托他在日本的弟弟代買日本信紙，并談及家事，勸嚴培南勸諫其弟的荒唐行爲，鼓勵族中弟子生活節制以求上進。

輯中另有嚴復致李經方、吳汝綸、沈敦和等友人信，除了涉及私事，還有關於北洋水師的公事。在寫給李鴻章長子，曾任出使日本大臣、出使英國大臣的李經方的幾封信中，我們知道李氏曾經在上海探望過住院的嚴復；而在另一封嚴復去世前半年致李氏的信中提到他對於北方冬天嚴寒的不習慣，福建老家天氣也冷暖無常，人事方面還多有不便，因此有了遷居上海的打算，給李經方寫信就是請他幫忙在上海代覓一處房産。給晚清桐城派重鎮吳汝綸的信札則提到兩件重要的事情：一是這年一月嚴復譯完亞當·斯密《原富》一書並將書稿寄給吳汝綸請求作序；二是這年五月他北上任開平礦務有限公司總辦，但信中提到公司人事、財政歸於西方人掌握，他這個總辦“實無所辦”，所以有時間做翻譯，此時《穆勒名學》翻譯工作也已經進行四分之一了。鑒於此，他對自己的事業想做另外的打算。另有致沈敦和信札乃嚴復任職北洋水師學堂時所作，信中主要與沈敦和討論三個選調教員到水師學堂任教之事，對於三人的薪水分配等事安排詳細，依此或可推定信爲嚴復任總辦時所寫，即光緒十九年（1893）四十歲左右。

中文信札之外，嚴復的幾封英文信也讓人眼前一亮，這些信札的内容提及頗多近代史事，自然也是可圈可點，而其流麗優美的英文書法更讓我們看到嚴復作爲一個翻譯大師那深厚且純正的西學修爲。

在給學生伍光建的三封英文信中，寫於光緒二十九年（1903）那封記錄了嚴復爲奪回煤礦權益一事所做的努力，在信中嚴復指出此案乃英商的欺詐行爲，同時認爲此事亦是袁世凱出於“水火門見之私”而故意刁難張翼，請伍光建建議張翼利用榮禄抗衡袁世凱。是信對研究清末開平煤礦中英權利糾紛提供了重要依據，也反映了清末朝廷的一些政治紛争。另寫於1906年10月的那通長信中多論國事，談及諸如清廷留學生選拔考試、丁未政潮前夕的京師政治格局等，從中可見嚴復在京師和政界要人的交游情況，從側面可反映嚴復此後個人遭遇變動的原因。另，信中顯示嚴復對京師政局的觀察和今日學者的認識頗有不同，故此信是重要的一手資料，極具史料價值。而致上海中西女塾友人英文信間接反映出嚴復對近代女子教育的支持和貢獻，是中國近代教育史的一則重要史料。中西女塾是上海一家由美國南方衛斯理教會所辦的女子學校，嚴復外甥女何紉蘭曾就讀於該校。

目録

中文信札

致李經方信札（四通）
尺寸｜ 17 × 26.3 厘米
材質｜水墨紙本

伯行大哥侍席啟者自己未秋間
奉別以還遲候忽再來春瞬惟
福履康強
潭祉佳勝為頌祝弟惟老弟以
老病頻侵居京不耐以茲空違登
病去年九月為此糧調亦家明天寒
室暖不學又以多事查水糧人多盛
種之之不便故近春極思糧涯公覺

一枝樓之流寓任友人代為覓宅但搜
西藏路云近末流界偽否日為寄屋極
少即洋式房屋亦須同此葉家一時弱
何彩黨為難各求須丙言否
兄居滬匈爭茲營覓為房某不審
意中可為相宜房屋可以出租采全村
〔旁註〕楊四處醫覺佳也
　〔旁註〕昌邱租金稍等孫力出而堪住否望

伯行大兄賜望高啟者日蒙
惠桂哥稱藉為暢溪稍詩積
懷但弟定糧明晚附搭新銘如
此行每之不相扱桂惆悵如
明葉妻友盛為沒末寓再海
的耳手此老弟即頌
秋祺不萱　世小弟嚴復沒表
　　　　　　　　　八月十七夕

此三四點兄佳先帝六情心
伯行等兄名座
午後校分萱侄行附時坐共車
專嗜姊早晨至云宗寄之時
高軒明於桂明日大態後赴家情
遲雲糧涂邱坐出
（下略）尺件事

一椽楼之远雅任友人代为品察但
四壁徒空连未流果居无时器有
少即洋式房屋亦须同此某家一时
俱野党为难名式情因无多多
瓷屋流免手蒸芸营置为房窑屋安
嘉申可为相宜房屋一可以出租来
楼回庭置蜀毂佳也
心写河积空穑罚孙力岁流十堪任了
言霉蜇轮近些如敷友为极司非之

伯行吾哥侍席啟者自己未秋間

奉寄以邁候忽再更寒暄竊惟

福體康強

潭祉佳勝為頌祝慰兄弟以

老病頻侵居京不耐以此告

病去年九月為此於閩而家眷天氣

宣暖不覺又以為苦去冬以來人不多識

種種不便故近來極思於滬上覓

伯衡大先賜謦欬高碻者

惠桂奇穗馮暢瀆稽穗

懷但弟定於明晚村搭詩

帖竹毋孙扢恂

顧棄表反威馮沒末窩

信耳此享弟即公頌

秋祺不宣世以弟頓首

伯珩老兄世大人執事久不

得雅報極切懷思惟性

安善而陰去滬特醫而目疾仍極為

一暌�[不]害何時

清賸雲尒專道涵極盛此情

秩禧

小弟嚴復頓首

己未八月初十

若以物遠條

福祉康彊

潭祉佳豫書

老病郵傷僑

莺起根扣惺思依
安善渔法去渡特
一睡不重回时
清眠雪永去遙道
秋禄小弟敲夜波

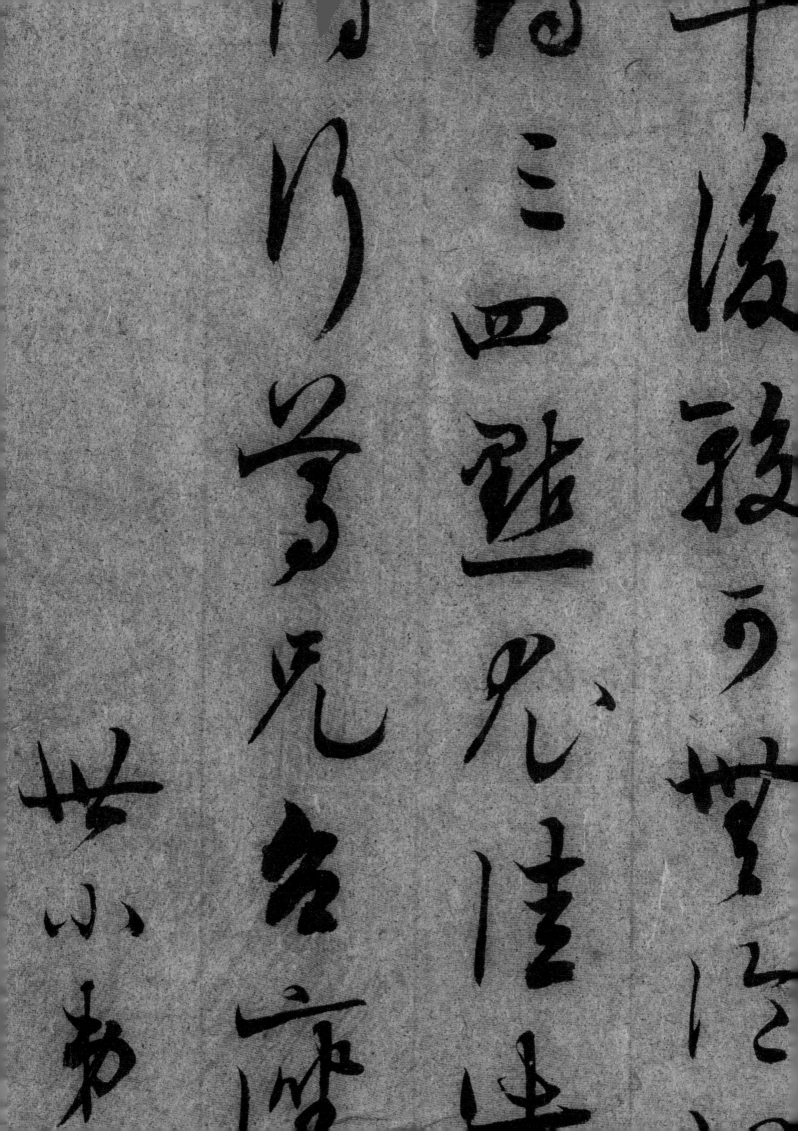

历沿幸

遏云栖涤郎诗

轩鸣桂鸣明

噫部早写

致吳汝綸信札
尺寸 ｜ 22.7 × 12.7 厘米
材質 ｜ 水墨紙本

輯甫先生惠鑒 昨日前曾郵一書并拙帖影

照西丹學案想經非有友赴保証貝韋並甲部兩冊

霽照籤後呈上譯例言十五條承示

勿政此二件并序皆南洋譯局兩待彙刻

宋書者即坐

加墨賜寄勿責俟通此此序非

先生堂北為者或者以獨箸而有兩觸裝浮

蒙速以深則光寵奉三開平鎮務自夏間合

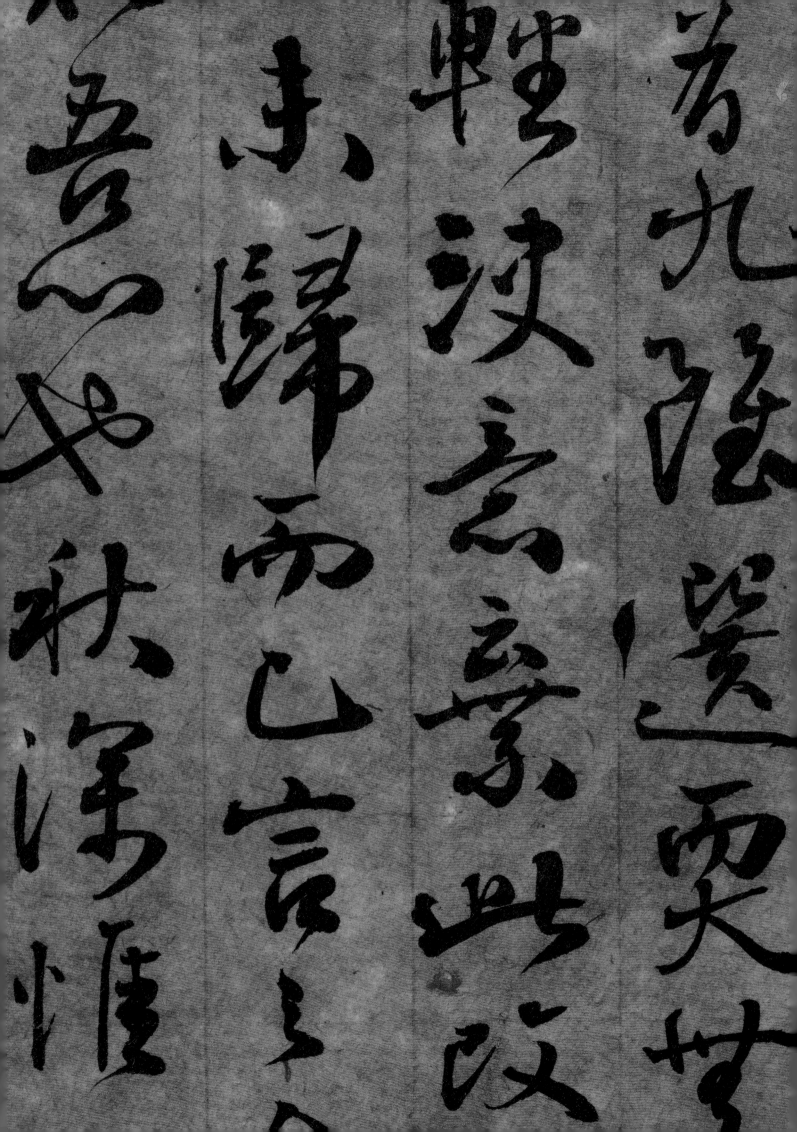

正申用人理至圓時

好辯宾望而以

得假器以後澤

然已了帙四分张

致沈敦和信札　　　　尺寸｜23.2×13厘米

材質｜水墨紙本

仲禮尊兄先生大人閣下：前遙調畫寫三

負刻已畢集津門需候

俟相繪製兩□前兩撥雲艇洋智即可繪

函覆三負前臨共非海軍係截至七月

底止如

甘棠前議以洞十月起支第四□去而以政為八月

起支清起記但該三負兩有經過迴盤川及

挪譽回兩語多務不稚為善求之欵且二三人

中陰費裘治外第係兩眼世怪軍晉撫童

郵政兩衙雷送學生外省礬川洸叱薄儞

□□□與所申因調配帥撥迴此洋別區

事□經內當舍專格迴達玄調兩更勿至知玄

月玄誰雨玉欲覓
嬉冥底因主搖犹
臨
於此三氣不稔
風観理尚見而悄後
用分乾松枳沒一名五十金

従子中郎少卿眈電兗嵊

奉報也峰鎻

軻復断

七月廿五

大哥招之到東假名云差後選
查河時以踐末滬迎親之約偽

方藥已寧金昨日起手照舊矣
阮府房東河時以出屋讓我
们搬進郵日子尚如鄰校至
由閩到此而芜乙半年矣

白露日书

再查正繕信封發之際接到紅十醫
院來單算至陽八月底此計住院六十
五日並他項滋費與銀規元四百四十四兩
八錢除籌款海林割治及九月以後洗
熨洪費尚未涧束大約起洲装热去
洋一千上下也此節可告根告大哥等知

同日又及

致嚴大、四小姐信札

尺寸 ｜ 25×14.5 厘米

材質 ｜ 水墨紙本

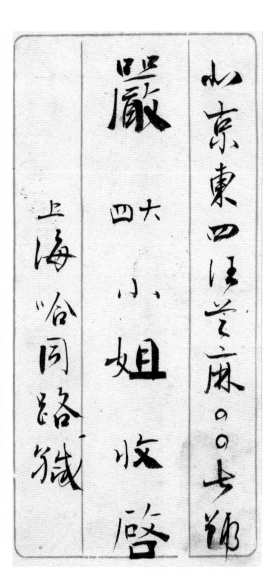

北京東四汪芝蔴○○書館

嚴四小姐收啓

上海哈同路獄

諭瑣頊等知悉今日節交白露矣
昨日天氣乃今夏嚴熱之尤甚
法倫表在蔭室之中乃至八十餘
桃葉席如蒸不能安睡直至子後五
鐘忽有暴風雷雨衝戶排牖
林帷姑稍涼爽乃睡至日旰表

降至八十又以近涼太快降深衣襟
涼而齦齶等處都作破林之如
以此三哥近善信來前書已云

降落八十又以近涼太快隆涼衣緣
涼雨體胃等暑都作暖棟燮安
河如何三哥近善信束前書昌云南
鶴松白窓話束滬不識克諸云啟
大哥於之到東但不云美致南
走河時以踐束滬迎親之約僑

諭璡等知悉今日邸差白諭璥
等昨日天氣乃今夏當熱之月然
法淪表在鑒室之中乃至八十五度
葯葉不囊
桃廗庶如葯不能安睡直至子後五
鐘忽有暴風雷雨衝戸撼牕
抹帳妨稍涼爽乃可睡至日清晨

再春正繕信封發之際接到紹平醫
院來單算玉陽八月底西計佳院卅
五月並他項滋費與銀規元四百四十兩
以後經算再除海林割治及九月以後洗
滌諸費尚未開來大約一起朋裝趁
洋一千上下也此節分告根去大哥等知之

同日又及

方藥已寫完昨日起予照依藥

院府一房東行時可以出屋瀧栽

衙搬進邸日子失如擲板檯

中開到此而兌已半年零

白露日云

裳在鑒察之中乃

如燕燕尔能安睡直

有暴風雷雨衝戶

如稍涼夹了睡兴

東河時雲出崖瀑

國相目出生如鄰板

此而光之半生

白雲語日出

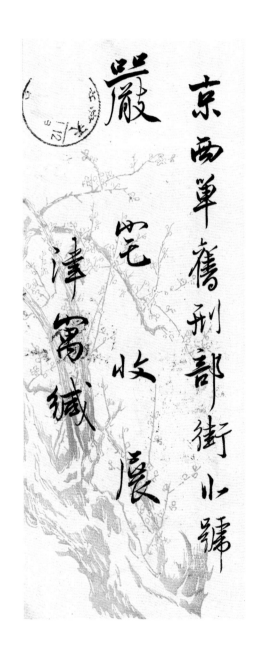

致嚴璸、嚴璆、嚴瓏、嚴頊四女有關占卜的家書
尺寸丨24×17厘米
材質丨水墨紙本

香嚴海森眉男知悉我到津寓

綏容克看過並給方藥現在夜間端咳

覺差胃口亦好大概林亭辦起課説十

自以後當日覺痙可又要靈了動身

早晚看容克言如何大約在初十邊

太遲六怕路上冷也今日又去清卷寶看

眼藥説四五鐘當来也華藥頓已全愈

甚念孃靓如 別近示多後好語大

哥當能道也 立冬日津寓

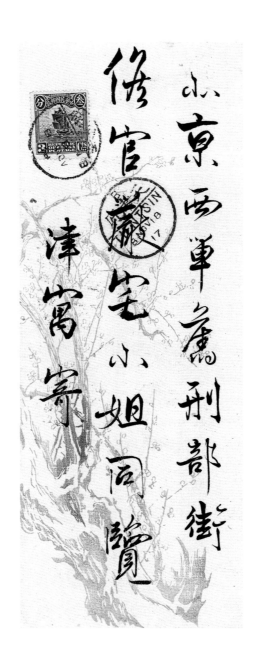

致諸子女有關返閩避寒的家書

尺寸 | 24×17 厘米

材質 | 水墨紙本

諸兒知其在津搭輪不覺已十六

日今晚九點一刻定同三哥與伯勳

搭津浦車南下榮克來過三四回

給藥五七種起先若有效到後不

過如此夜睡好時有六點工夫有時又

復不好濯洗有一種吸藥惜京津毫

有用時當有奇效此餘均安好勿念

戊午十月十六日在津寓泐

汝大哥有法想否前間照辰說浦口站有前水師壶蘊學生
院開又字光驗肺見月市中有黑暈
吳夢蘭者在彼當差彼有努力為先以信託之以備簪
兩靈一近右肩一去右邊月市底前約
或今力車相候於老人甚者滴也善照辰尚在京口叫大哥
有拇指大後則甚浸而小醫云吾之
就近詢之或另川想法切之
喘欬即此為紫蓋黑暈所呈即緣

肺葉發炎血脹作硬所致耳此
是送老痛但天氣對妣善藥可
稍鬆耳可告孃等知之

辛酉二月初三日父泐

北京東城大阮府胡同十五

嚴眉男 收閱

福州邸官巷九號

字諭瓊瓏頊等知悉 為父日來稍

差福州天氣已是春深昨夜雷始

發聲 今日又晴明也吾長居一小樓

足不出户故稀見聞無甚可述但使

可以支持擬穀雨後立夏前回京

自上海到津目二姊會晤畢故不擬坐船以但坐火車

剔一蹞車站月台吾高望貴東不又而子甫立月台為此甚不如

致嚴瓊、嚴瓏、嚴玷論北上行程
並提及水師學堂的晚年家書
尺寸 ｜ 38×27.5 厘米
材質 ｜ 水墨紙本

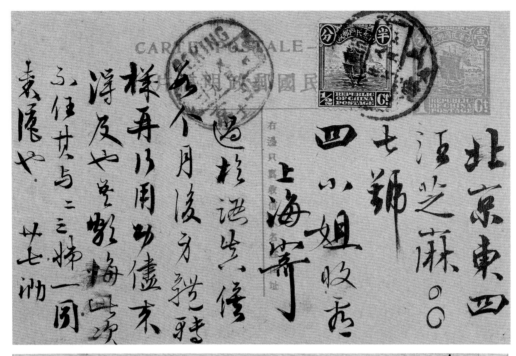

致嚴項明信片

尺寸｜13.7×8.8厘米

材質｜水墨紙本

柬闕功太過須知少

筆用功本甚佳事

細看為此轉致鈍體

力受傷便是愚事

古人云三三便之為毛

洵玉表兄金家則於初六日勤身赴滬

想初八後已至上海矣伯玉尚妄信來不

知寄家何處江姨同出與否傳陽崎吾

吾皆不知也汝父間一時不能南去將遣

孫貴先歸措取冬天衣服不知兇麼

有所聞吾弟近日頭暈心跳日甚待之

寫信半紙時几案欲旋須閤筆伏几少

時乃蘇細思想亦鵡片作祟也吾兒千

祈自愛新遷室陽光較多夜間寒

暎如何被褥當神勿令受凍切之中秋夜助

樹影一庭月華艷灔..........

對此幽清不覺百端交集

致何紉蘭信札

尺寸 ｜ 40.5 × 17.5 厘米

材質 ｜ 水墨紙本

本晨發去昨稿所繕快信想已接

到本日未得來書不知廿四日體中

何如殊深憬系日來境感遇秋不

勝悲又不欲以落寞無聊之詞來瀆

新愈人視聽中情抑鬱殆不能堪帖

不能搆棄一切即行到津兩校事待

理惠部中有取易校長之說華以

借松院中人仿照清華學校前案

辦理道須將校產保險始去合同為

此又須延閣保險者係天津良鴻緒所

始有回信此事一星期內不知能了

結否真足令人不耐也本日聞吳曾有

時乃蘇細思想

駕信來紙膊駕

者兩聞罗逆

想初後
已

知審家何處

吾皆不知也海

將校虜衆保論

保險險者保天津

此世事一星其期

卻卽行到津

自取易校長

本仿照清華

康遇未人言之極穩凡今日流謂快意
者皆他日喪失自由之資故革固不能
然亦須猛著節制嗜夫人生禍患皆伏
於得意之時汝先弟近日生理頗有得
手之勢望深察吾言自施以廑勒馬
手段則後福正無窮耳吾於汝審泰

居一日之長呈以不憚頹絮作為此言
吾為不言更呈無人言者連日報端
皆云福州吃緊吾八月中原擬與瑞
書同返但事勢如此一時然又不得成
行吉月何時到西城可順便看我一
讀此事此事託即問
近好

燮忠手沖七號

致嚴培南信札

尺寸 ｜ 26×17 厘米

材質 ｜ 水墨紙本

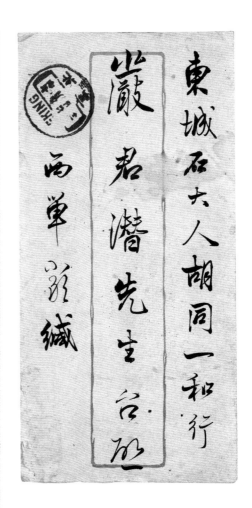

君潛賢姪如見 多時不面想都安
好生理當益發達幾情、閱嘉井
尚左日本不審何時當歸有玄書
時煩囑代愚買日本信紙十捲但要
質潔理細不須太講究也更有切囑
者吾看嘉井近來於女色上面頗形
沈溺中年人此事於體氣根基甚
有關係汝為其兄似當要攬勸諫

至於示費淺財即吾其欠引

君潛償縣如見多時不面想都安
好生理當益發達極清，閱豪井
當去日本不審何時當歸有玄書
時煩囑代覓買日本信紙十捲但要
質潔理細不須太講究地更有切囑
者吾看嘉井近末格女色上面額那
沈瀚中生人此事於體氣根基甚
有關係汝為其兄似當要挑勸諫

至於浪費錢財抑居其次閒

慣梁盡於煙霞一道亦有進境此事

家過來人言之極稔凡今日所謂快意

者皆他日喪失自由之資故革圖不能

然亦須猛省節制嗜夫人生禍患皆伏

於得意之時汝先弟近日生理頗有得

手之勢望深察吾言自施於隆勒馬

手段則後福正無窮耳吾於汝甫泰

居一日之長是以不憚煩絮作為此言

吾端不言更是无人言者連日報端

皆云福州吃緊吾八月中原擬與瑞

常圖返但事勢如此一時恐又不得成

行去何何時到西城可順便看我一

讀也乎此幸託印問

近好

弟志沖士瑞

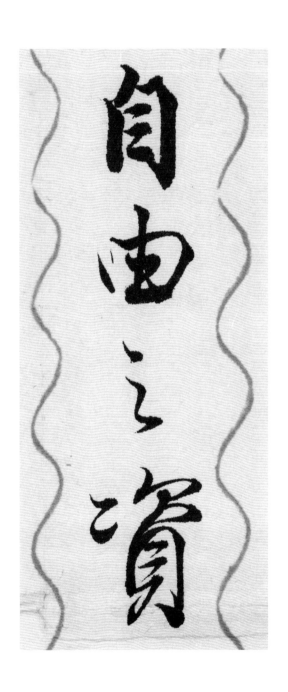

自由之資

何時當歸有玄
均本信紙十捲但
太講究也更有十
束粗女色上面題

之時汝先弟近日

當深察吾言當

後福正善安期正

嚴復爲尚書廟籌款事致翰周、又槃侄信札

尺寸 | 13 × 23 厘米

材質 | 水墨紙本

詔園

又紫

業雲十一月十七拜梁病中以慰喜已倡云稣掬

管作蒼耳朝用洋織眠連鄰悃熱已收覽

五剤病稍愈陵晚詢目眩已代多審催遺

此亰中同鄉陳彼菴太傑陳玉茗故菴子

矣緦去雲以組次長曾雲沛搓長喜皆有喜

緘益緣灣前亲可惜柯貞兵以放洋維此國

六可謂為凌函而已本日已有信与李智軍催

使招事又与南中海軍羅傢稚間喜進力

此何想早晚与浮朱写喜並臺而歸了

我此生之病竟較去年為重肌削欣銷風吹

許多已觀此等如書更可見而又乏豪不能見

貞狂均達前浮十月十三日藏去尚去一病

顧惜名工稈峁為敉宾此條吾堀他震揺可到此

英文信札

his Excellency Chang & he is trying to use one Chinese who is most influential as a weapon against another or whom he wishes to gain a victory. Our apprehension is indeed not ground-less. For he has already kept up private correspondence with Tang the Custom Taotai. And permit Chuang Yu Sing to retain his position in the Comp'y while he is appointed by Yuan to be a member in his Bureau of Foreign Affairs. This Collegian of ours is very traitorous in his character which is well known to everybody who has a deal-

Tientsin. 16th or 17th March
2. am

My dear Woo,

I would have written a letter to His Excellency Chang if there was time for me to do so: but as the messenger wishes to return to Peking tomorrow I can only scribble these few lines to you.

The clouds are evidently gathering from every quarter, and the parties who are guilty in the matter are now feeling uneasy. His Excellency can infer very much

from the reports which Detring has written him secretly. He, according to your letter, attributes the effect to Kingsley vigour; but Detring thinks rather differently and puts it to the doings of Dr. McNiel. Although each of them has his own part to play, but Kingsley, so to speak, is still in the reserve & does not assume the fighting position. But on the other hand McNiel is authorized by the Committee to proceed & can make his

(2)

with him, both Chinese and Foreign. You know Yuan has the "dare devil" in him & he will accompany the Court to the Western Tomb soon; whenever opportunity offers itself, most probably he will avail it again to attack Chang. Detring thinks that it will be well for His Excellency to test the reliability of Yung-tsung tang's support as soon as he can. If he can depend upon Yung-lu for

the support against Yuan through thick and thin then there is nothing to be dreaded. If His Excellency be not certain in this, it would be much better, he thinks, to let Yuan have the thing which he craved, provided that he will take the whole responsibility and consequences. Let His Excellency employ Yung-tsung tang as a bridge to shove this burden over to Yuan peaceably. It

致伍光建英文信一、二　　　　尺寸 ｜ 21.6 × 26.4 厘米
　　　　　　　　　　　　　　材質 ｜ 水墨紙本

...e felt to these wrong

...the letter from Chang
Deting promised to
...it and will draw
...it out as soon as he
...

...there is one thing which
...pies our mind most.
...is our apprehension
...ill-timed & ill-advised
...of that ambitious
...Viceroy Yuan. Mr
...the Agent & General
...of the Company is
...aware that some
...existed between
Yuan &

...letter for China at
...the above be a good
...to His Excellency or
...shall say nothing.
...better to let His
...know how the
...lands & provide
...tingencies.
...ill be in the Capital
...22d this morn &
...& see you and
...Money is soon as
With kind regards
Yours sincerely
Y. Fuh

except. Let him summon up full
moral courage! Do what
he thinks right! & Do not
be influenced by other considera-
-tions. They will follow
suit, & thus he shall have
nothing to repent or to fail
him.
 I remain
 My dear Woo
 Yours faithfully always
 Y. Fuh

P.S. Your Honour will of course
convey the full meaning of the
content of this letter to His Exc.y
He must remember, that it
was His Excellency himself who
put Kingsley to this line of action,
∴ to defeat Kingsley's plan is to defeat his
own

momentous consideration for
His Excellency is "How he shall
proceed to the solving of the
problem". The Committee
here is evidently jealous of
Kingsley's success and do not
like the idea that he should
be looked upon as the
Saviour of Company. Even
Deting is not free from
such baser sort of sentiment.
I had a talk with him last
night and I can see him
through and through. Those
who are concerned in the matter
are now not only wished to
get out of the mire financially
intact but also with their names
unimpeachable.
 It is high time now,
therefore, that His Excellency
should be firm & clear-headed
in giving his order to charge &

Tientsin 20th April 1903
Dear Mr Woo
 Many thanks for
your very pleasing letter of
yesterday. When I wrote it
I meant to take the enemies
inner redoubt of their failures by
storm; & hence I took the bull
by the horns & dealt at the
very beginning, the question of
"fate". If the public be really
enlightened by my article I hope
all future blows which may
deal at His Excellency will be,
at any rate, powerless. Deting
congratulated me heartily &
he admired my valour in putting
my name to such an article.
This was obliged by the circum-
stance & I ...
... Now the ...

by whom, the column shall be
lead. Do what is just &
right & do not let other
petty interests influence him.
 I can see through
Kingsley's communication that
he must have been supported
by very reliable forces behind
and it would be unjust of
His Excellency to drop him thus
abruptly. In a word, if
His Excellency means thoroughness
of the work: then take Kingsley's
advice and proceed. If he
means Compromise, then follow
Deting with whom he will have
Hanneken, Detring, Fisher
Robertson & dozen others who
were more or less accomplice in Hoover &
Moreing's plan somehow. His
Excellency knows these better than
we do. To say more is superfluous.
I, therefore, will say nothing

from the reports which
has written him recent
He, according to your
attributes the effect to
vigour; but Detring r
rather differently, and p
to the doings of Dr M
Although each of them
his own part to play,
Kingsley, so to speak,
in the reserve & does
assume the fighting po
But on the other hand
i authorized by the Com
to proceed & can make

influence felt to those wrong
doers

Re the letter form Chang
to Thys Detring promised to
think over it and will draw
the rough out as soon as he
can

But there is one thing which
now occupies our mind most.
and that is our apprehension
of the ill-timed & ill-advised
meddling of that ambitious
but weak Viceroy Yuan. Mr
Wynne the Agent & General
Manager of the Company is
evidently aware that there is some
difference existed between
Yuan &

the support against [...]
through thick and thi[...]
there is nothing to be [...]
of His Excellency he [...]
certain in this. It [...]
much better, he think[...]
to let Yuan have th[...]
which he craved, [...]
that he will take th[...]
whole responsibility a[...]
consequences. Let [...]
Excellency employ [...]
tsungtang as a bridge[...]
shove this burden ov[...]
Yuan peaceably.

will be better for China. at
least.

Whether the above be a good
advice to His Excellency or
not I shall say nothing.
But it is better to let His
Excellency know how the
matter stands & provide
for all contingencies.

I will be in the Capital
on 21st or 22nd this morn &
will come & see you and
His Excellency as soon as
possible With kind regards
 Of yours sincerely

except. Let him summ
moral courageous! &
he thinks right! & &
be influenced by other
-ations. They will f
suit, & thus he shall
nothing do defeat was
him.

I remain
My dear lo
Yours faithfully

P.S. Your Honour will
convey the full meaning
content of this letter to
He must remember,
was His Excellency, him
put Kingsley to this line
∴ to defeat Kingsley's plan is to

Tientsin: 20th. April 1903

Dear Mr. Loos

Many thanks for
your very pleasing letter of
yesterday. When I wrote it
I meant to take the enemies
inner redoubt of their fortress by
storm; & hence I took the bull
by the horns & dealt at the
very beginning, the question of
"Sala". If the public be really
enlightened by my article I hope
all future blows which may
deal at His Excellency will be,
at any rate, powerless. Detring
congratulated me heartily &
he admired my valour in putting
my name to such an article.
This was obliged by the circum-
stance that I am clear...
for doing so. Now the most

momentous consideration
His Excellency i 'Hon
proceed to the ordin
problem'. The Co
here is evidently jealou
Kingsley's success and
like the idea that he
be looked upon as
Saviour of Company
Detring is not free fr
such baser sort of
I had a talk with
night and I can see
through and through
who are concerned in
are now not only wis
get out of the mire
interest but also with the
unimpeachable.

It is high ti
Therefore, that His Exce
should be firm & clea
in giving his order to Ch

by whom, the column shall be
lead. <u>Do what is just &
right</u> & do not let other
pettry interests influence him.
I can see through
Kingsley's communication that
he must have been supported
by very reliable forces behind
and it would be unjust of
His Excellency to drop him thus
abruptly. In a word, if
His Excellency means <u>thoroughness</u>
of the work: then take Kingsley's
advice and proceed. If he
means Compromise, then follow
Deting with whom he will have
Harmetan, Dickinson, Fisher
Robertson & dozen others who
were ^more or less accomplice in Hoover &
Morcingo' plan somehow. His
Excellency knows these better than
we do. To say more is superfluous.
I, therefore, will say nothing

from the oxford
has written h..

He, according
attributes the
rigour; but
rather differen
to the doings
Although each

which Delane

recently.

your letter,

feel to Kingsley.

tains thinks

and puts it

Dr McNeil.

of them has

by whom, the
lead. Do n
night & do
paltry interests
I can s
Kingsley's com
he must hav
by very reliab
and it would

olumn shall be
et in just +
ot let others
influence him
through
munication that
been supported
forces behind
he unjust of

Hsieh Pu
Peking
18th October 1906
1/9/32.

My dear friend,

Since my arrival in Peking, which dated on 23/8/32. your image has often come up to the mirror of my mind; and I really wonder why you were not called to attend the examination. Well, I think I better describe the proceedings rather fully for I know that it will interest you and our friends Doctor Cox and Mr. Chang. &c.

The candidates amounted after all 41 in number, & there are 20 from Europe and mostly America. & 21 from Japan. About their accomplishments, of course, those from Japan bear really no comparison with those from America & Europe. Beside the few from Shanghai, they are mostly protégés of Tang Hsao Yi. The High Examiners appointed by the Decree were originally four, viz. Tang. H.Y. Lian fang, Ing-chang and Takesan representing four languages English French, German & Russian. Ing-Chang, however, does not relish such kind of work; he made an excuse & went in haste to his newly appointed post in the Yangtse Valley. So there are now three High Examiners with Tang at their head. Six of us are Assistant Examiners, three from Tientsin & Peking, they are Dr Watt J.C. Messrs. Woo Susan and Tsang Tsin Yeo (the railway engineer of Nalgan and Peking line). And the remaining three are from Provinces they are Monsieur Oui-Han, Mr Liu 劉子貴 and my humble self. Each one has his proper subject to look after, that is to draw out the questions and to read the pamphlet.

(2)

As most of them are each has only one ... deal with. I, ... a general reader am ... are better hand to sup... six subjects, to wit ... mies, Law, (Consti- -national) Commerce Book keeping &c. America can hardly ... so they are allowed to ... in foreign languages ... Japan can present ... in Chinese or Japan... thing are had to do ... their Diplomas whe... and noted down the ... which they attaine... -mitted to be candi... no diplomas or Col... ofer. The grades ... given to the successf... Tsin-sye & Chü Jin ...

To understand well, you must bear in mind that there is no such thing in the present discussion as Constitution. There are now two parties with Yuan and Tieh as their heads. Apparently they want to carry out a thorough reform in the whole system of Executive organism in the Empire, and thus begin with the Imperial Council & Boards. Yuan desires to avail the opportunity to paralise the power of Tieh, who has now the Army, the Finance and the Decreeing of Officials in his hand. On the other hand Tieh means to strengthen the Centralisation. Tuan-fang, Chang Po Hee are of Yuan's supporters, And Yume Chin and Kü-Hungkee of Tieh's. Tieh knows well that the new system is to his ruin, so he resists deadly against it. and Yuan does find not that it is too strong for him. You see, they work severally to their own interest. Duke Tsai tseh & Prince Chune

(3)

Mr Li Chiatü told me it is far much harder & more regular than that of the last year. Tang, of course, is the absolute ruler of the whole thing and he has the interest of so many his young men to look after. As to Mr Oui Han's & my coming up here, it was not, I am almost sure, initiated by Tang. That may give you some hints to solve the question "Why you and Mr Koo H.M. were talked but not summoned up after all?" It is because we are not of his party. The Vice president my name-sake is most kind and deferent to us three or rather two. And the Presid. Yume Chin is also very affable. For he asked me to spend more times in Peking and invited me to be live in his house. He is indeed very much flattered by my coming up so promptly to his call.

So much for the Examination. Now let me tell you something about the proceedings of the said Constitution.

(4)

are these perhaps wh... the reform, but they ... heads. The confl... Central and Province... daily become severe... helps of railways a... favours the centre... naturally, and they ... of ability Tieh is ... Yuan. If the lat... trol him now, then... will be the master... saw Ch'ang Po Hee... requested me as a ... Yume tsin to secon... but that is a task ... for one to take up. ... Yuan will leave th... the review, so I ... this early morning ... chap was there, but... after 3 long hours... because I think, ...

was examined with three questions
& two only were required to be answered;
the time allowed was unreasonably
ample that is from 8 a.m. till dark.
They had been mustered twice, viz.
27 an 29th of 8th moon. Now
the papers are in due order.
Dr. Chen Kin-tao comes
out easily the very top of them and the
second I think is W. W. Yen of St.
John's College. The former was exam.
in Economics & the latter, philosophy.
so you see they are both candidates
of mine. On the second time
they were requested to write an Essay
the theme was "Whether it is advisable
Compulsory education in China."
Those who cannot are supplied with
a Chinese theme for Chinese Essay —
I have all the Chinese to peruse.
On the whole the examination has been
decently conducted. If I may criticize
it is perhaps too easy & it tends to
lower the value of the honour. But

The appointed committee have
two Boards, one Senior and one Junior,
the former with Prince Chun as its
President & the latter is presided by
our friend Sun who is now the
Mayor of the Capital. My son
has been appointed by Duke Tséh
a member of the junior board &
the young Pekinese are very jealous
envious of him.
I hope to leave Hueh Pu
soon; after that perhaps I will stay
for ten days or so to make a round
call on old acquaintances. & then
will start for Tientsin
With kind regards, kindly
remember me to Dr. Cox and
Chang (they enquired after the latter
& I told him that he intends to go to
Japan, with recent loss of his brother
in law he was obliged to stay &c)
Yours sincerely
Yen Fuh

致伍光建英文信三
尺寸 | 22.9 × 17.6 厘米
材質 | 水墨紙本

Hsüeh Pu,
Peking
18th. October 1906
1/9/32.

My dear friend,

Since my arrival
in Peking, which dated on 23/8/3.
your image has often come up
to the mirror of my mind; am
I really wonder why you were so
called to attend the examination
Well, I think I better describe it
proceedings rather fully for I know
that it will interest you and our
friends Doctor Cox and Mr Chang.

The candidates amounted after
all 41 in number, & there are
20 from Europe and mostly America
& 21 from Japan. About the
accomplishments, of course, those for
Japan bear really no comparison wit.
those from America & Europe.
Beside the few from Shanghai, they

mostly protégés of Tang Hsao-Yi. The High Examiners appointed by the Decree were originally four, viz. Tang. H.Y., Lian-fang, Ing-Chang and Takésiou representing four languages English French, German & Russian. Ing-Chang, however, does not relish such kind of work; he made an excuse & went in haste to his newly appointed post in the Yangtso Valley. So there are now three High Examiners with Tang at their head. Six of us are Assistant Examiners, three from Tientsin & Peking, they are D. Watt J.C. Mess. Woo Susan and Tsang Tsin Yeo (the railway engineer of Kalgan and Peking line). And the remaining three are from Provinces they are Monsieur Ouï-Han, Mr. Liu 劉子貞 and my humble self. Each one has his proper subject to look after, that is to draw out the questions and to read the pamphlets.

(2)

As most of them are specialists, so each has only one or two subjects to deal with. I, unfortunately, being a general reader and because they have no better hand to employ, have five or six subjects, to wit, Philosophy, Economics, Law, (Constitutional & International) commercial knowledge & Book keeping &c. Those from Europe & America can hardly write any Chinese so they are allowed to write their answers in foreign languages; but those from Japan can present their work either in Chinese or Japanese. The first thing we had to do was to inspect their Diplomas whether they are O.K. and noted down their grade of honor which they attained. No one is permitted to be candidate if they have no diplomas or College Calender to refer. The grades of honour to be given to the successful candidates are Tsin-sze & Chü Jin. Each subject

was examined with three questions
+ two only were required to be answered;
the time allowed was unreasonably
ample that is from 8 a.m. till dark.
They had been mustered twice, viz.,
27 & 29th of 8th moon. Now
as the papers are in due order, ~~~~~
~~a rather~~ Dr. Chen Kin-tao comes
out easily the very top of them and the
second I think is W. W. Yen of St.
John's College. The former was exam.
in Ecomies + the latter, philosophy.
v. You see they are both candidates
of mine. On the second time
they were requested to write an Essay,
the theme was "Whether it is advisable
compulsory education in China."
Those who cannot are supplied with
a Chinese theme for Chinese Essay —
I have all the Chinese to peruse.
On the whole the examination has been
decently conducted. If I may criticize
it is perhaps too easy & it tends to
lower the value of the honour. But

To understand well, you must bear in mind that there is no such thing in the present discussion as Constitution.

There are now two parties with Yuan and Tieh as their heads. Apparently they want to carry out a thorough reform in the whole system of Executive organizm in the Empire, and thus begin with the Imperial Council & Boards. Yuan desires the to avail the opportunity to paralise the power of Tieh, who has now the Army, the Finance and the Decreeing of Officials in his hand. On the other hand Tieh means to strengthen the Centralisation. Tuan-fang, Chang Po Hee are of Yuan's supporters, An Yume Chin and Kü-Hung Kee of Tieh. Tieh knows well that the new system is to his ruin, so he resists deadly against it. and Yuan does find not

Mr. Li Chia Ku told me it is far much
harder & more regular than that of the
last year. Tang, of course, is
the absolute ruler of the whole thing
and he has the interest of so many
his young men to look after. As to
Mr. Oui Han's & my coming up here,
it was not, I am almost sure, init-
iated by Tang. That may give you some
hints to solve the question "Why you and
Mr. Koo H. M. were talked but not summoned
up after all?" It is because we are out
of his party. The Vice president my
name sake is most kind and deferent to
us three or rather two. And the Presid'
Yune Chin is also very affable. For
he asked me to spend more times in Peter
and invited me to be live in his house.
He is indeed very much flattered by

are those perhaps who have a mind for the reform; but they are mere figure heads. The conflict between the Central and Provincial Powers will daily become severe. But with the helps of railways and telegraphs, it favours the centralisation of powers naturally, and they say that as a man of ability Tieh is quite equal to Yuan. If the latter could not control him now, then, in the end, Tieh will be the master of the field. I saw Ch'ang Po Hee last night and h requested me as a patriot to persuad Yune tim to second Yuan's move; but that is a task too momentous for me to take up. As I knew that Yuan will leave the capital soon for the review, so I went to the garden this early morning to see him. The

The appointed committee have two Boards, one Senior and one Junior the former with Prince Chune as its President & the latter is presided by our friend Seun who is now the Mayor of the Capital. My son has been appointed by Duke Tséh a member of the junior board & the young Pekinese are very jealous envious of him.

I hope to leave Huesh Pen soon, after that perhaps I will stay for ten days or so to make a round call on old acquaintances. & then will start for Tientsin

With kind regards, kindly remember me to Dr Cox and Chang (they enquired after the latter & I told him that he intends to go to Japan, with recent loss of his brother

aralise the p
the Army, t
eening of Office
their hand Th
Centralisation
e ase of Yuan
e Chin and J

...ower of Teeh," ...
to Ferrance an...
...ils in this ham...
h means to str...
Tuan-fang...
's supporters,
...i. Heng Kee,

aturally, and
abiliti, Teih
uan. If the
ol him now,
ll be the meas
w Ch'ang Po
quested me as
me him to see

hey say that, as
is quite equal
latter could not
tern, in the end
of the field
last night.
patriot to per
Yuan's on

76, Old 'Hsin-Pu' Street,
West City, Peking.

19th November 1916

My dear Neph,

Upon the receipt of Pouhyen's letter I am glad that after all he is now with you and that has relieved one of my great anxieties. Under your constant brotherly supervision, except his health, I have nothing at present to be uneasy. Pouhyen has many good qualities which will not shame our family; but he is wilful and has a great deal of self-conceit in him. As he is now drawing near to his majority and his education cannot be said to be well accomplished. I, as his father, have the bounden duty to see that his precious time must not be unworthily wasted. I went to see Dr Reisch, the American Minister, the other day, in order to see that

there may be some
Legation will ret...
date, so that he
with him. The
let me know at o
opportunity; and
advised me not
meantime. Re
have already laid
the time comes he
a hitch. To ord
this needs not be
we need now is to
prepared. In
he cannot go any
Not only with Mat
that you can impart
experiences as a s
can give him man

致嚴伯鋆英文信

尺寸丨25.3×20.2 厘米

材質丨水墨紙本

76, Old 'Hsin-Pu' Street.
West City, Peking.

connected with the
America in a near
ke my boy to go
it has promised to
on there be such an
same time he strongly
the boy be idle in the
cational expences. I
the money. so when
ach at once without
ission he will take.
d at present, what
he boy generally
bresent circumstances
better than to you.
and other sciences
, but form you own
in the States you
le advices that

76, Old 'Hsin-Pu' Street.
West City, Peking.

will be wise of him to follow.

It gave me intense pleasure to see our
cousin PoKien the other day when he came here
to bid farewell to me ere starting to his new
post in Szechuen. The youth is not only intelli
gent, but he is energetic and plucky which is
very rare quality, among the younger generation
of our house. I can almost foretell that he
is sure to strike out a worthy career of his own.
I am old now. you can understand what
satisfaction it gives to me in seeing our youngsters
are doing well in struggling for existence in such
troublesome world.

Ponhym talks about making foreign costumes
in Tang Shan: he said it is cheaper to make there.
Well, you can guide him in this respect also.
Whatever you think proper I will agree and
send you the money. With loves to all
your affectionate uncle

76, Old 'Hsin-Pu' Street,
West City, Peking.

19th November 1916

My dear Neph,

Upon the receipt of Pouhyen's letter I am glad that after all he is now with you and that has relieved one of my great anxieties. Under your constant brotherly super-vision, except his health, I have nothing at present to be uneasy. Pouhyen has many good qualities which will not shame our family; but he is wilful and has a great deal of self-conceit in him. As he is now drawing near to his majority and his education cannot be said to be well accomplished. I, as his father, have the bounden duty to see that his precious time must not be unworthily wasted. I went to see Dr Reisch, the American Minister, the other day, in order to see that

76, Old 'Hsin-Pu' Street,
West City, Peking.

there may be some one connected with the
Legation will return to America in a near
date, so that he can take my boy to go
with him. The Minister has promised to
let me know at once when there be such an
opportunity; and at the same time he strongly
advised me not to let the boy be idle in the
meantime. Re' his educational expenses, I
have already laid aside the money, so when
the time comes he can start at once without
a hitch. To what profession he will take,
this needs not be settled at present, what
we need now is to have the boy generally
prepared. In view of present circumstances
he cannot go anywhere better than to you.
Not only with Mathematics and other sciences
that you ˄can impart to him, but from your own
experiences as a student in the States you
can give him many valuable advices that

76, Old 'Hsin-Pu' Street,
West City, Peking.

will be wise of him to follow.

It gave me intense pleasure to see our cousin Pokien the other day when he came here to bid farewell to me ere starting to his new post in Szechuen. The youth is not only intelligent, but he is energetic and plucky which is very rare quality, among the younger generation of our house. I can almost foretell that he is sure to strike out a worthy career of his own. I am old now, you can understand what satisfaction it gives to me in seeing our youngsters are doing well in struggling for existence in such troublesome world.

Ponhysn talks about making foreign costumes in Tang Shan: he said it is cheaper to make there well, you can guide him in this respect also. Whatever you think proper I will agree and send you the money. With loves to all
 your affectionate uncle
 Yen Fuh

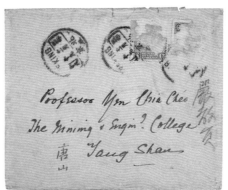

…bia farewell t…

…in Szechuan…

…t, but he in en…

…aare quality…

…wr house. o…

…rre to strike e…

…in old now.

one are starti

The youth

getic and plea

among the you

can almost

t a worthy

one can unders

ome one conne

eturn to Amer

he can take

The Housilow ha

once when t

A the sea

76, Old 'Hsin-Pu' Street,
 West City, Peking.

...ded with the
...ea m a near
...y boy to go
... promised to
...re be such an

McTyieres' School
Shanghai. China.

14th Jan? 1907

My dear Madame, Your welcome
letter came to hand yesterday and
I am glad to learn that you past
so merrily your time in the Continent.
Do not think that I have forgotten
you, because I have not written you
as often as I wished. Since the
summer I had been rather poorly
but I am glad to tell I am much
better now. The school work
occupies much of my time and you
know that I am a slow girl
& hence I have to study hard in order
to get along with my comrades.
This is the reason why I did not
write you & moreover I do not know

You have stay
think of you n
& you image
before my m
any You told
n to be in the
but it is now
suppose it took
then three wee
so I my letter
you in the m
moon & I fo
happy face as
letter comes t
you couple poo
honeymoon tou
in the continen
so France - so
Switzerland _ so

致上海中西女塾友人英文信
尺寸 | 21.3 × 27.8 厘米
材質 | 水墨紙本

...t the time. I
then wishe you
...p involuntarily
...ge.
that your happiest
of this month.
...ay 13th & I
...least 2 more
...each you
...ll be handed to
...f your honey
I see your
smiled when this
. Well, where
...t pass your
It must be
...fancy — Italy
...g the lakes in
...re in Cairo as

you told me before.

You must excuse me ~~that~~
if you find the letter not so long
as I wish; because my exam
draws near & I have very little
time indeed to spare. Ah!
my parents in law are now
in Shanghai & they are both as
well as they could be. I will
remember you kindly to them when
I return to their quarter.

In the mean time receive my
best wishes for your marriage
& many happy returns.

I remain

yours affection...

J-Lang yen...

your time in the Continent
think that I have forgotten
cause I have not written you
as I wished. Since the
I had been rather poorly
glad to tell I am much
. The school work
much of my time and you
I am a slow ~~fellow~~ guy
I have to study hard in a
with my comrades.
reason why I am not
& moreover I do not

took at least 2 more
weeks t reach you
letter will be handed to
midst of your honey
I fancy I see your
which smiled when the
to you. Well, where
proposed t pass your
tour. It must be
hmmm I fancy — Italy
or among the lakes

圖書在版編目(CIP)數據

嚴復信札選輯/鄭志宇主編;陳燦峰副主編. —
福州:福建教育出版社,2024.1
（嚴復翰墨輯珍）
ISBN 978-7-5334-9858-0

Ⅰ.①嚴…　Ⅱ.①鄭…　②陳…　Ⅲ.①漢字－法帖－
中國－近代　Ⅳ.①J292.27

中國國家版本館 CIP 數據核字(2023)第 237738 號

嚴復翰墨輯珍
Yan Fu Xinzha Xuanji
嚴復信札選輯

主　　編：鄭志宇
副 主 編：陳燦峰
責任編輯：陳玉龍
美術編輯：林小平
裝幀設計：林曉青
攝　　影：鄒訓楷
出版發行：福建教育出版社
出 版 人：江金輝
社　　址：福州市夢山路 27 號
郵　　編：350025
電　　話：0591-83716736　83716932
策　　劃：翰廬文化
印　　刷：雅昌文化（集團）有限公司
　　　　　（深圳市南山區深雲路 19 號）
開　　本：635 毫米×965 毫米　1/8
印　　張：14.5
版　　次：2024 年 1 月第 1 版
印　　次：2024 年 1 月第 1 次印刷
書　　號：ISBN 978-7-5334-9858-0
定　　價：118.00 元

如發現本書印裝質量問題,請向本社出版科(電話:0591-83726019)調換。